For

Linus and Tristan
Lucy
Barnaby and Oliver

Acknowledgement and appreciation to

Ali
Dinah
Tim
Bella and Dawson

A 10% donation from each direct sale goes towards an ocean clean up charity.

ISBN: 978-1-8380094-0-3

Published by BLLOT Publishing. Bllotpublishing@gmail.com
Printed by CLOC Ltd, Tottenham, London

The Pony spent most of his day staring out to sea, waiting for the floating island to return.

One morning, after months of being alone, he saw a large box on the beach below, and trotted down to take a better look. The tide washed up both familiar and unfamiliar items but this box was nearly as big as his shelter. He went to touch it with

his muzzle, it was hard, cold and smelt of sea. There was a noise from inside, it sounded like the silver birds when they zoomed fast overhead.

The Pony walked around the box a few times trying to find some sort of hole. He kicked it but that just made him feel wobbly. He bit it but that just hurt his teeth. Then he saw a handle he could push with his nose, he pushed and pushed until a door opened with a slow creak. In the darkness he saw some red lights moving towards him and the noise was louder.

The Pony backed away, what had he released?

A voice said, "Battery low, please charge now... battery low, please charge now."

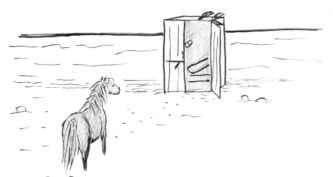

A hand slowly reached around the door, then another hand, followed by a head, a body but then only two legs.

The Pony knew this shape meant danger as they take what is not theirs to take.

This thing though just stood on the sand with its head bowed towards the sun. The Pony stood staring at it but then wandered off to graze.

Sometime later, the shiny head started to move, red lights had turned green.

The voice now said, "Battery charged, reboot and downloading 85% complete."

The Pony was not as fearful as he had been, so he bravely walked up to it and gave it a good sniff, nearly knocking it over.

"What are you?" asked the Pony.

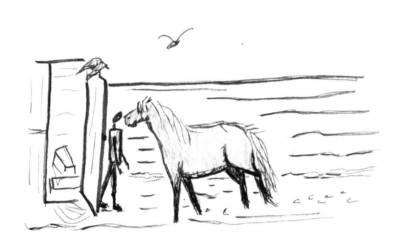

The object copied the Pony but it had no nose, so just knocked his head against the Pony and replied, "I am M.A.N. - Machine AssistaNt version 11-11 – limited edition, man-made to your specific needs. Are you the Nixon household of 1960 Mead Road, Dana Point, California? I am here to lighten your day. Please show me where the laundry room is or the kitchen. I adapt to any environment."

The Pony watched this man-made Man as he looked up and down the beach.

"Adaptation taking place...I do not compute," Man said. Man asked again where the laundry room was. The Pony looked at the sea and said, "Well, I wash myself in there." Man looked at the Pony and replied, "Please remove your clothing and I will wash them."

The Pony half snorted and half laughed, "I cannot remove my coat!" Man did not understand, his programming told him that everyone wore clothes that could be washed. He went up to the Pony and pulled his mane.

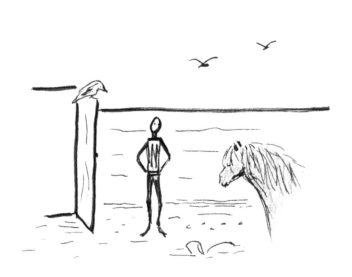

"Ow!" shouted the Pony who bit Man but the hard surface hurt the Pony.

"What is Ow?" asked Man.

"Ow is when something hurts," said the Pony.

"What is hurt?" asked the Man.

"When you pulled my mane, it hurt and caused pain. Do you not hurt?" asked Pony.

"I am 100 per cent recycled plastic," said Man.

"Does that mean you cannot feel anything?" questioned Pony.

"I cannot," Man replied tapping his arm.

The sun was beginning to set, the Pony turned to go back up the hill and into his shelter for the night. Man followed the Pony to a building that was possibly an old house. It had part of a roof, holes where doors and windows had once been but it also had a tree growing through the middle and brambles climbing up all over, there was a dry corner where the Pony slept.

"Can I bring you a refreshment or perhaps you would like to watch a movie? I have over five thousand movies, documentaries and television programs installed," Man offered.

"What does that mean?" asked the Pony.

"Suggesting options," replied Man.

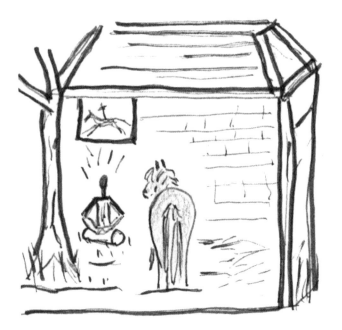

Man started beaming images from his eyes onto a wall, a film with a train. The Pony watched mesmerised as it moved along a track, smoking from the top of its head like the floating island.

The changing of clips went on for quite a while with Man repeating after each, "Choose an option, choose an option." A clip of galloping horses came up, the Pony spoke "Option."

The Pony and Man watched the Western until it finished. The Pony then slept.

With the warmth of the sun on him the Pony awoke. Man, too, had the sun pouring into his battery pack, the green lights now fuller than ever.

The Pony recalled the film he had seen during his sleep time, about his mother and friends being chased, frightened, by the loud herd-catchers on the buzzing crates and how they had trapped them on a big floating island. The Pony had watched,

as the island moved further and further away until it was no longer there.

Man was able to understand that what the Pony had described was a round-up and that, perhaps, his herd had become domesticated so that little men called children could sit on them and control them like the movie he had seen the previous night. The Pony remembered the stories of the great gathering that had been told to him by his grandmother.

The Pony, with Man
following, headed over to
the lake for a long cool
drink. Some trees had
fruit on them and the long

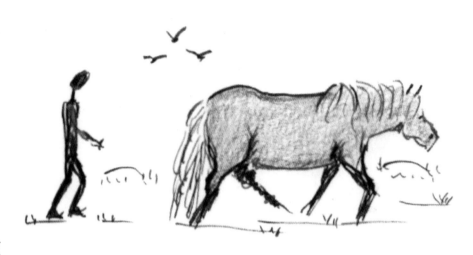

grass was beginning to dry. As the Pony grazed, Man walked

about clicking and speaking to himself "cornflower, Red

Admiral, dog rose, scabious, heather" as he directed his head

at different flowers, insects and shrubs, every so often he

would announce, "saved to database."

The Pony looked longingly at the apples which were beginning to ripen and he really wanted one. He rubbed his backside against the trunk, nothing dropped, he kicked it, still nothing. He had an idea.

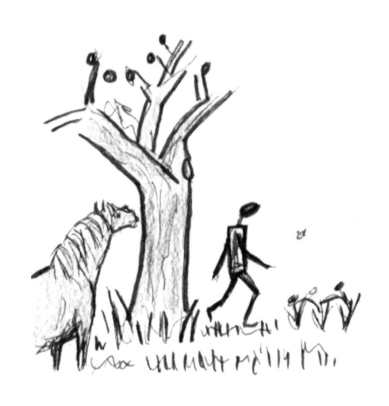

"Man," Pony asked "Could you get on my back and reach those apples?"

Man was keen to be of assistance, after all, this is what he had been made for.

"I can fulfil your request," replied Man.

Man stood next to the Pony and tried to mount him like he had seen in the movie. Man tried all different ways unsuccessfully until the Pony, bored, started to eat again.

When he put his head down, Man clambered over his neck,
then when the Pony lifted his head up in surprise, Man slid on
to his back even though he was facing the tail end, Man was
still able to reach the biggest apples and picked as many as he

could. The Pony shook Man off and he fell clutching them tightly. The Pony ate them all, one by one, what delight as he savoured each mouthful.

Man watched and asked, "What is it like to taste?"

"It is different every time, depending on what I eat," the Pony replied. "This apple is sweet and sour. Grass is only juicy first thing in the morning or when it is new, clover tastes sweeter."

How can you explain taste wondered the Pony.

"Can you smell, touch or feel anything Man?"

"I cannot smell," Man responded, as he picked up an apple and handed it to Pony. "I can touch but I cannot feel." Pony pondered as he ate this last one. How can you touch without feeling? And what was it like not to smell? How could you smell the change in the weather, or feel warm rain on your back during a summer shower, or the sea splashing up when you galloped along the beach? Actually, that could sometimes hurt if he had a cut.

"What else can you do?" asked Pony.

"I can record anything. I know where you are and where you want to go. I can tell you the moon phases. I can tell you the temperature anywhere. I can tell you the time in each zone. I can help relax your heart rate or speed it up. I can wake up your children or switch them off. All this is brought to you by my unique algorithms, designed to lighten your day."
These words made no sense to the Pony apart from making him think that Man could do a lot of stuff.

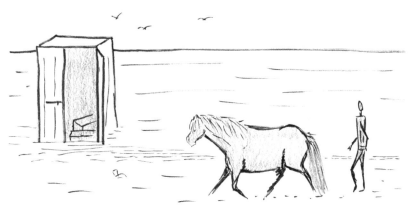

Man and the Pony walked down to the beach and back to the crate, inside could be seen the wet, broken boxes of all the other M.A.N.s.

"They are dead," Pony sadly said.

"No sun, no power," Man said with no sadness.

Man spoke "cuttlefish, crab, plastic bottle" as they walked along the beach. The Pony loved the smell of the sea and he loved to feel the sand under his hooves as he sank slightly with every step. The Pony realised that actually each and every breath he took was unique, every little step, big or small was always different, the Pony walked into the sea to cool down and make sense of this new thought, he then swam. Man watched from the dry shoreline. Clicking away and announcing every so often, "saved to database".

The Pony thought some more and realised that he was able to somehow absorb life through every part of his body. On the outside he could touch, see, taste, smell and hear, but on the inside, he could feel warm or cold, empty or full, depending on what he thought about. Was this "saved to his database"?

When he reached the shore, he asked Man if he wanted to ride again. Man liked this idea. Once dry he put his head down and Man mounted like he had done before, making sure that he was facing the head end this time as he slid down his back. The Pony started walking, Man gripped tightly with his legs as

he bounced about, the Pony went faster and faster like he had seen in the film. With Man firmly in place, they felt as one, the Pony galloped up and down the beach, scattering gulls as they thundered past.

Then Pony suddenly stopped, Man fell head first onto the sand, the Pony was holding up a leg.
"Are you broken?" said Man.

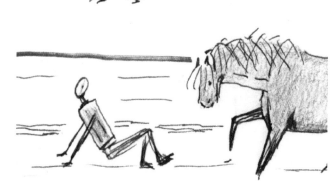

"No, I have something biting me," the Pony said. "Can you get it off?"

Man, carefully pulled out a large fishhook that was embedded in his hoof, after which the Pony went and stood in the sea to soothe the pain.

The Pony and Man spent many days on the long beach where they had first met. Man had adapted to his environment and had started to collect all the washed-up rubbish, carefully making different piles for wood, plastic and rope. Sometimes they would kick old balls about or Man would ride. Every day the tide brought in new items, Man had found an old hat to wear, one boot and some sort of plastic sheet. He made a

halter for the Pony with various pieces of rope, and now had reins so he could hold on better and also lead him about, whether the Pony liked it or not.

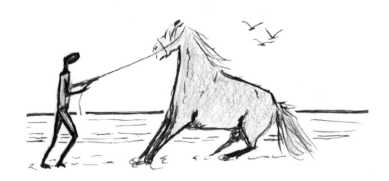

These weeks helped to fill some of the emptiness the Pony had been feeling. Although Man had no instinct he did have some

sort of intelligence, the Pony only knew what he knew from his surroundings and from his grandmother, her story. Man was teaching him new things...how the sun and moon influenced this planet called Earth...about the seasons, which explained why there was sometimes no grass or more than enough grass...how a boat was the only way to reach an island.

The Pony would go to sleep with all sorts of new thoughts in his mind, but in his dream time he always talked to his grandmother about missing his mother and friends, her wise words were always the same:

"Dear child, see in your mind's eye your mother returning and feel that joy in your heart, the power of thought and intention can create worlds..."

But the Pony would wake feeling heavier each day with his sadness. Man could not understand, the Pony looked the same on the outside but something was not quite right.

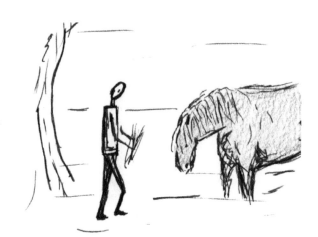

The Pony had become slower and less eager to leave the shelter, as if his battery needed charging. He spent more time sleeping and was also beginning to drip from his eyes. Man did not compute, how can he fix something that did not seem broken? He tried to find the reset button but Pony was not man-made and could not be simply rebooted, all he could do was gather grass.

Man, though, liked to be busy and spent his days on the beach and his job of tidying it up.

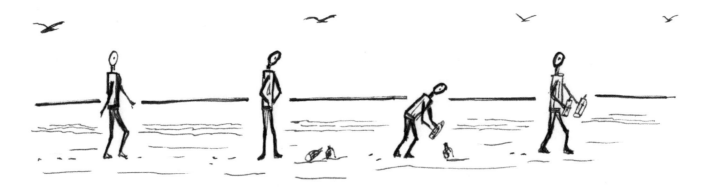

One day, whilst there, he heard the noise of an engine. When he looked up, he could see a boat approaching. He walked back to the shelter and woke the Pony to tell him. The Pony felt excitement return to his body like an electric shock and with Man on his back, he got up and went to his usual look-out. Could it really be his mother and herd returning?

The boat was definitely heading towards them.

When it stopped, the ramp was dropped and the gates were opened. The herd charged out and raced along the beach, galloping as fast as they could up to the headland. The Pony galloped to meet them with Man holding on tightly as the Pony jumped logs and the stream in his haste to reunite.

Finally, they were all together, the Pony felt such joy in seeing everyone again. His mother nuzzled him, what love he felt as all his sadness dropped away.

She then noticed that he had something on his back.

"What is that on you?" she asked.

The Pony explained the whole story to the herd and how Man although similar to the herd-catchers was also very different. The sun seemed to feed him, his cracks never healed, he could not feel hot or cold, love or fear and his voice never changed volume.

Man meanwhile had dismounted and taken himself back to the beach. The herd-catchers were baffled at these new piles of rubbish. Whilst some started loading them onto the boat another headed along the beach to find out who exactly had tidied up. He saw Man approaching.

"Are you the Nixon household of 1960 Mead Road, Dana Point, California?" asked Man.

The herd-catcher replied, "No, but we can make sure you get there, if you come with us."

The Pony with his herd around him watched from above, as the herd-catchers left with all the rubbish and Man, this time taking what was theirs to take.

The End